Illuminated Alphabets

*In memory of my wonderful parents
who gave us all so much when
they had so little.*

PATRICIA CARTER

Illuminated Alphabets

SEARCH PRESS

First published in Great Britain 1991
Search Press Limited,
Wellwood, North Farm Road,
Tunbridge Wells, Kent TN2 3DR

The author would like to thank her family for all their co-operation and help, and also Julia Rowlands for editing the manuscript.

ISBN 0 85532 710 3

Publishers' note

There is reference to sable hair and other animal hair brushes in this book. It is the Publishers' custom to recommend synthetic materials as substitutes for animal products wherever possible. There are now a large number of brushes available made of artificial fibres and they are just as satisfactory as those made of natural fibres.

Composition by Genesis Typesetting, Rochester, Kent
Printed in Singapore

Contents

Introduction

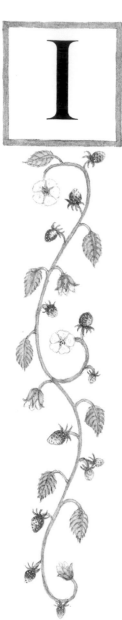

The decorated letter has been a feature of handwritten texts since earliest times. In this book I show you how to design and decorate your own alphabets. I do not attempt to teach the art of calligraphy, as there are many excellent books on the market to do just that. Rather, I have aimed these pages at those of you who already have some knowledge of calligraphy and who wish to add colour to your work in the form of illuminated capital letters. This book complements my first book *Illuminated Calligraphy* in which I show how to create borders to enhance your calligraphy.

Illumination is the embellishment of a letter or text with gold and colours. Some of the most beautiful illuminated manuscripts ever seen were created during medieval times. They were produced by monks working in scriptoria, the writing rooms of the monasteries. Usually, the manuscripts were the work of several hands, as the details of writing and decoration were separated and assigned to different craftsmen. By today's standards, the conditions under which the scribes and illuminators worked were primitive. They toiled for long hours in cold rooms, working by candlelight and using handmade quill or reed pens. They wrote on animal skins and produced their paints from natural pigments which were ground into powder form and mixed with a binding agent before being used. Yet, the works that they produced were quite awe-inspiring. Many medieval manuscripts have survived the ravages of time and can still be seen today in museums, libraries and universities around the world. It is worth looking at some of these works to experience at first hand their beauty and detail.

With the advent of printing in the fifteenth century the role of the scribe declined. It was not until Victorian times that there was a renewal of interest in handwritten texts and illumination, and, through the work of William Morris (1834–96) and later Edward Johnston (1872–1944), the skills of the medieval era were revived.

Today, decorated letters are used for a wide variety of purposes, from traditional works such as charters and memorial books, through to ephemeral pieces such as birthday cards and invitations. They are not even restricted to illuminating calligraphy, and are often modified and used for crafts such as pottery, wood carving and embroidery.

In this book you will find a number of alphabets, ranging from the simple to the more complex, and suitable for a variety of occasions. I hope that they will appeal to you and inspire you both to try creating your own designs and to explore the art of illuminated letters in greater depth.

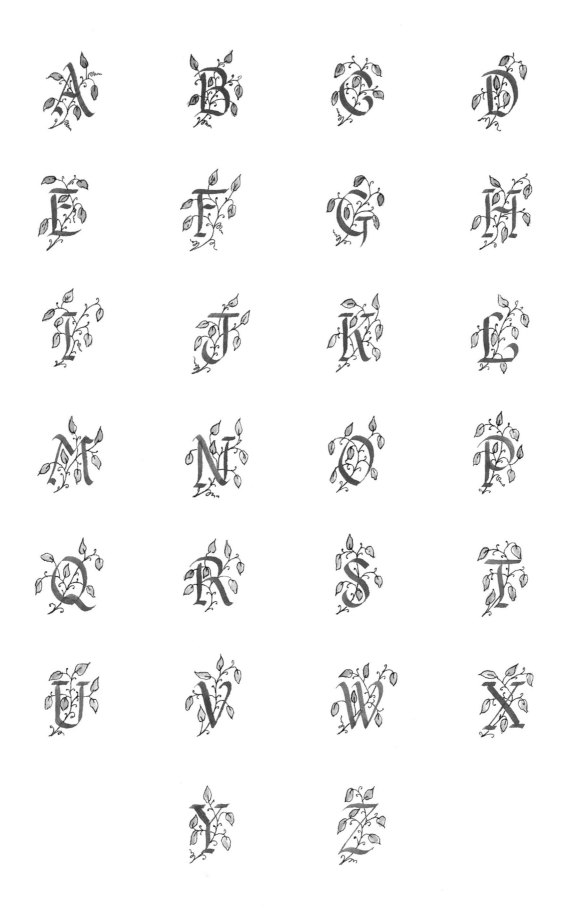

Tools and materials

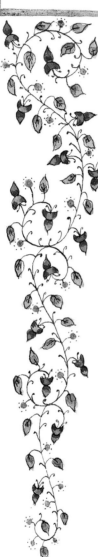

Today, there is a bewildering selection of tools and materials from which to choose. However, it is not necessary to acquire a wide range straight away, as the essential requirements for decorating capital letters are relatively few and inexpensive. I suggest that you begin by buying the basics only, following the guidelines in this section. Then, you can build up your range of equipment gradually, as you become more experienced and have had time to decide on your preferences. Remember, when buying any equipment, to select the best that you can afford, as the better the quality the longer the item should last. Your most frequent expense is likely to be the replenishment of supplies such as paper, paints and gold leaf.

Working position and surface

A suitable work surface and a comfortable working position are both essential for calligraphy and illumination. It is possible to work on a flat surface but it is less tiring to use a slanting one. Many people find an angle of forty-five degrees ideal. However, you may discover that you prefer a steeper or a shallower slope, so experiment until you find the angle that suits you best. It is also important to use a good comfortable chair that is the right height for you, as this will help to prevent backache.

A large working surface is not necessary for most projects and a medium-sized stout piece of plywood makes a perfectly adequate drawing board for decorating books and small broadsheets. This can be angled by propping it against a pile of books. Clearly, if you are working on a very large design, then you will require a larger board. Whatever size you use, make sure that you rest it securely against the table, otherwise you could spoil hours of work with just a single slip.

You may decide to buy a small desktop drawing board from an art materials supplier. There are a variety on the market, most of which can be adjusted to the desired angle. Some also have parallel rules attached to them which are useful when ruling lines.

It is a good idea to place a pad of three or four sheets of blotting paper under your work. This gives a springy surface on which to work and is preferable to the hard, smooth surface of the board. An extra piece of paper positioned under your 'working hand' will help to protect against grease and smudging.

Paper, vellum and parchment

Paper There is a huge array of papers available, ranging from rough to smooth and suitable for all types of media. Handmade papers are the best for important pieces of work, although they are rather expensive and can be difficult to obtain. For beginners, I would recommend a good quality cartridge paper. I used an acid-free cartridge paper weighing 150g/m$^2$ for all the alphabets in this book. Often, I use a line and wash paper, or, when I am planning to frame the work, a line and wash board. This needs no mounting and is easy to frame. For planning designs and alphabets I use large amounts of inexpensive copy paper. I find tracing paper essential for transferring my designs onto my final piece of paper or vellum.

Vellum This is more expensive than paper, but it is the surface traditionally preferred by calligraphers and illuminators. It is prepared from calf, sheep or kid skin. For a very special occasion it is well worth the extra expense.

Parchment It is still possible to buy parchment. Prepared from the inner layer of sheepskin, it is much more delicate than vellum, although less expensive. You can also buy imitation parchment which is cheaper still. Occasionally I do use parchment, but I find it is difficult to remove mistakes from its slippery surface.

Pencils, pens and brushes

Pencils These are available in a variety of grades which indicate their degree of hardness (H) or blackness (B). In the H range, the higher the number the harder the lead and the lighter the line it makes. In the B range, the higher the number the softer the lead and the blacker the line it makes. Between the two ranges is the general purpose HB pencil which is medium grey. There is also an F grade pencil. This does not smudge as easily as a B pencil but is blacker than an HB one.

I always use hard pencils for sketching and designing, making sure that I keep a sharp point on them at all times. I use 2H and 2B pencils for tracing letters and designs, and a 2B pencil when working on vellum. Do not use a pencil any softer than 2B on vellum as soft lead smudges easily, and these smudges are extremely difficult to remove without spoiling the delicate surface of the vellum.

Pens Quill, reed, and metal-nibbed pens can all be useful for the artwork surrounding a capital letter. I suggest that once you have mastered the basic techniques in this book, you try and experiment with as wide a variety of pens as you can. For very delicate and detailed work I often use a fine, high quality technical pen and a mapping pen.

Brushes Good quality brushes are essential for illuminating initial letters and it is advisable to spend as much as you can on a small selection. I find sable brushes the best for my work. Although these are expensive, they will last for several years if cared for properly. For all the alphabets in this book I used sizes 000 to 4. This range is ideal for detailed work as well as for painting larger areas in the bigger capital letters.

Cheaper, ox hair and squirrel brushes can be used, but they do not last as long as sable brushes and lose their points sooner. It is also possible to buy synthetic brushes made from nylon or polyester. These are strong and cheap, but I find that they do not make a very good tip and do not hold colour quite as well as a sable brush.

Always wash your brushes carefully and reshape the tip after use. To protect the tip, make a small tube of paper, drop it over the head of the brush and secure it with a piece of sticky tape.

Inks and paints

Inks I have found that coloured inks are not very satisfactory for illumination. Although some of the colours are brilliant, they are inclined to fade, and I have noticed also that some of the inks have a tendency to bleed. However, I do use black indian ink for drawing fine details.

Paints Choosing paints is a matter of personal taste and only with practice will you discover your preference. For very fine detailed work I use watercolours, finding them particularly suitable for the small designs surrounding capital letters. In quality, artists' watercolours are far superior to student watercolours and they are also more permanent. They are sold in pans, cakes and tubes. Pan and cake colours have to be moistened with a brush and rubbed to loosen the colour. Tube colours are more convenient to use and can be mixed easily. However, they do have one drawback; the paint is inclined to dry up on the palette, which can be wasteful. It is important to remember that watercolours become lighter in tone on drying.

Gouache is ideal for painting capital letters. If it is applied fairly quickly, then it does not streak like watercolour does. It also has the advantage of being opaque which means that any mistakes can be painted over easily. Like watercolour, gouache is sold in tubes, cakes and pans. The pans and cakes need to be diluted with a moist brush before use, whereas the tube colours are ready for immediate use. However, I tend to find gouache too thick when applied straight from the tube and I usually dilute it. Care should be taken when mixing, as some of the colours lose their brilliance and become muddy in appearance.

I sometimes use acrylics, although I find them a little heavy for

delicate work. They dry very quickly and, like gouache, they darken in tone on drying. They can be mixed with water or used straight from the tube.

Ready-ground powdered pigments can be used. These colours are pure and strong, and most resemble the type of pigments used in medieval manuscripts. However, they are expensive and need to be mixed with a binding agent, such as gum or egg, to make them adhere to the painting surface. I would not recommend them for the beginner as they are a little difficult to prepare.

Other materials

Erasers I use a soft white eraser for removing pencil marks. Coloured erasers should be avoided as they can stain the surface of the paper. Care should be taken when removing pencil marks from vellum, as harsh rubbing can damage the delicate surface or cause the marks to smudge and smear. Use a hard rubber gum or soft rubber to remove unwanted lines.

Craft knives A sharp knife with a good quality blade can be used for scraping off ink errors, provided that the ink is completely dry before the mistake is removed. A sharp-bladed knife is also required for sharpening pencils.

Geometrical instruments A ruler with both imperial and metric measurements is needed for ruling up lines, and I often have need of a set square, T-square, compass and templates. If you look in a good art shop, then you may find sets of templates in circles and various curves. These can be very useful for designing alphabets. When using a compass for drawing circles, I find it better to make a template on a separate piece of paper. This avoids the paper or vellum being damaged by the compass point. The other alternative is to use a stencil.

Palettes A palette is needed for mixing paints, although you can improvise by using clear white saucers or small jars. Try to avoid mixing colours on a coloured background, as this could show through a transparent paint and affect the colour being mixed.

Cleaning materials Keep plenty of old rags and white blotting paper handy for cleaning equipment after use.

Gilding equipment For applying gold leaf, special equipment and materials are needed and these are listed in the section on gilding techniques on pages 14–15.

Colour

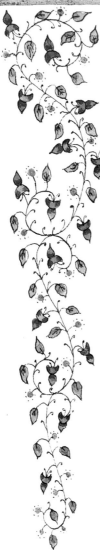

Colour plays an essential part in the decoration of capital letters. The next time that you see a rainbow, look carefully at its beautiful, crystal clear colours, perfectly blended. Alternatively, hold a crystal pendant up to the sunlight and watch how the sun catches the facets, producing sparkling, clear colours. This is how your illuminated initial letters should look when they are painted.

Of course, it takes practice to be able to blend colours successfully, and, for many beginners, choosing a colour scheme and deciding which colours go together can be very confusing. It is helpful to look at the manuscripts of other calligraphers, both medieval and modern, and see how they have used colour in their work. However, I think that the best way to develop a practical understanding of colour and how it can be used is to experiment with your own work.

Always try out the colours that you wish to use on your capital letter and surrounding design first. Put them down side by side on a piece of scrap paper and experiment with different arrangements until you are satisfied that they blend well. Keep these sheets of experimental colour blending. They can provide a valuable source of inspiration for future projects, especially if you make a note on each of the colours that you have used.

When deciding on your colour scheme, take time to plan the whole page. Sometimes, the verse or quotation itself may set the scene and suggest the colours to be used. Do not use too many colours in your design as this can result in a muddled effect. The beautiful illuminated manuscripts of the Middle Ages were produced using a very limited palette. To give balance and rhythm to my designs, I always repeat any colour that I use. Also, I take care to match the colour of the initial letter to those in the surrounding design.

It is important to bear in mind the purpose for which your illuminated design is intended. A rainbow effect may look wonderful on an informal birthday invitation or a greetings card, but it would not be appropriate for a formal document or an inscription in a book of remembrance. When working on formal pieces, I always use either blue, black or red for painting the initial letter.

It is worth remembering that the use of colour is largely a matter of individual taste, and what appeals to one person will not necessarily appeal to another. It is only with practice that you will discover your own preferences.

Choosing your palette

Obtain as large a variety of colour charts as you can from a good art materials supplier and study these carefully before making any decisions. If you are a beginner, then a basic range of colours is all that you require. A suitable palette consists of a selection of blues, reds and yellows together with a few auxiliary colours. For my work, both in miniature painting and book illumination, I use the following in watercolours: yellow ochre, cadmium yellow, vermilion, violet alizarin, ultramarine, viridian (or alizarin green), lamp black and Chinese white. I do use a wider range of colours in gouache as some of these paints do not mix well. Traditionally, gold is not regarded as a colour and is treated as a separate element, additional to the overall colour scheme (see section on gilding on pages 14–15).

Mixing colours

A vast range of colours can be mixed from a basic palette of blue, red, yellow, black and white. Once you have organized your palette, experiment with mixing the primary hues, yellow, red and blue, using the colour chart shown here as a guide. When mixed together, red and yellow produce orange, red and blue produce violet, and yellow and blue produce green. Orange, green and violet are known as secondary colours. Tertiary colours result from mixing a primary colour with a secondary colour, e.g. blue and green when mixed make blue-green. White added to these colours will produce tints, whilst the addition of black will produce shades.

When working on a design, always mix more colour than you think you will need. If you run out of the mixture before your initial letter is finished, then you will find it almost impossible to match the colours exactly.

My basic palette and the colours shown here in the colour chart form the basis of all my work. You may wish to mix a wider range of colours, or you may prefer to buy extra colours and add them to your palette as you require them. The choice is entirely yours.

Gilding techniques

The richly illuminated manuscripts of the Middle Ages still provide some of the finest examples of gold decoration. Today, as in medieval times, gold is generally reserved for special and prestigious pieces of work. It is used for capital letters and ornamental border designs, and occasionally for whole lines or even blocks of text. There are a variety of methods which can be used to apply gold or at least achieve a gold appearance on your designs.

Inks and paints

There are a number of gold pens, inks and paints available. As these tend to tarnish and darken, they are most suitable for small items that will not be kept for any length of time. I use them on my rough layouts when planning the colours.

Shell gold

This is used with distilled water and is more permanent than inks or paints. It can be made up using real gold powder, or it can be bought ready prepared. The making-up process is fiddly and I recommend using the ready prepared solution. This was originally sold in small shells – hence its name. It is now available in small pans or in tablet form. Shell gold is ideal for fine detailed work and for small dots of gold. It can be applied using a fine sable brush and, once it is dry, it can be burnished. I always apply shell gold after my other colours because it has a tendency to run, although it can be thickened by adding a little gum arabic.

Gold leaf

Although it is more difficult to apply, I prefer to use gold leaf for my designs. Its lovely finish makes the extra effort worthwhile. I suggest that you try the technique on a piece of scrap paper before attempting it on your finished design.

If I am creating a design in which the whole initial letter is to be in gold, then I always apply the gold first. However, when using gold for minute details, such as dots and thin borders, I prefer to leave its application until last, because the tiny areas of gold have a tendency to flake off. Always take care not to touch or disturb the gold once it is in position, as any handling will cause a dulling of the surface. As a protective measure, it is a good idea to place a piece of paper under your hand and over the completed design.

Materials Fine sable brush; water matt gold size (or gesso); book of gold leaf; small pair of sharp scissors; tweezers; thin paper; sharp craft knife; soft paintbrush; agate burnisher.

Gold leaf can be purchased in small packs containing a few leaves or in large books containing many leaves. Burnishers are used to polish the gold and are available in various shapes and sizes. Size or gesso is used to create a sticky surface upon which the gold is laid.

fig 1

Method Gold leaf must be applied on a flat, clean, hard surface. A slanting surface could cause the size to run and form puddles at the base of the design.

Firstly, draw out the design, see Fig.1. Mix the size or gesso with water to a fairly thin consistency, and brush it evenly onto the paper or vellum, see Fig.2. If tiny bubbles appear, then pop them with a pin. Leave the surface of the size or gesso to dry out until it is slightly damp and sticky to the touch. If you are intending to gild several areas, then apply the size or gesso to all the areas.

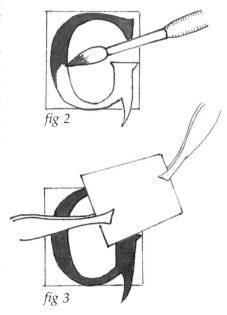

fig 2

When the surface is ready, cut a piece of gold leaf using clean, sharp scissors. To ensure that the whole area to be gilded will be covered, cut the gold a little larger than is required. Cut through the backing paper and the gold leaf, holding the cut piece with tweezers, see Fig.3.

fig 3

As the gesso or size needs to be fairly moist or sticky, breathe on it a few times to prepare the surface. Gently press the gold leaf face down onto the size or gesso, with the backing paper still in position. Hold the paper firmly. Place a piece of thin paper over the backing paper, pressing down lightly with your fingertips. To transfer the gold onto the design, rub the tip of the burnisher over the whole design surface and the edges as smoothly and quickly as possible, see Fig.4.

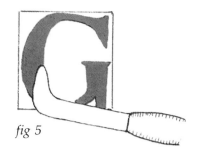

fig 4

Remove the 'rubbing' paper and backing paper, and gently brush away any stray pieces of gold with a clean, soft brush. Any ragged edges of gold can be tidied up by scraping them off carefully with a sharp craft knife. It is advisable to burnish the gold when the size is dry, so wait for about fifteen minutes before you start. Make sure that the burnisher is clean or it could damage the surface of the gold. Using light, circular movements, rub the burnisher over the gold until it starts to feel smooth. Then, move the burnisher in straight lines across the gold to achieve a lovely bright finish, see Fig.5.

fig 5

ow to begin

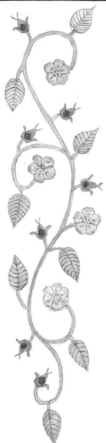

Designing your own alphabets is not only a challenge, but can be fun and very rewarding too. In this book I have brought together a whole range of decorative alphabets, suitable for both the beginner and the more advanced student. By practising and experimenting with these letters, you will soon gain the confidence to start creating your own designs. Whatever design you choose, the basic techniques required to produce the letters will remain the same.

Design ideas

Design plays an essential role in calligraphy and illumination. Whether you are interpreting the words of a chosen text or simply decorating a name, your finished piece of work should be harmonious and pleasing to the eye.

When choosing a design for a capital letter, the text, style of calligraphy and border decoration must also be considered, as they all play an integral part in the overall feeling of harmony and balance. If a border design is called for, then the surrounding design of the initial letter should complement it and not clash in colour or style. Most of the illuminated alphabets in these pages will blend with the designed borders in my companion volume *Illuminated Calligraphy*, although some of the more elaborate letters are best displayed on their own with suitable lettering. If too much decoration is displayed on the page, then the work will look cluttered. The spaces on a page are as important as the design itself, and the composition of spaces, lettering and decoration must have an underlying rhythm.

Try to ensure that the subject matter of your design relates to the content of the text and to the calligraphic hand in which the text will be written. Often, the subject matter of the text will suggest a suitable topic for the design. The occasion for which the work is intended will also have an effect. Formal documents, such as certificates, deeds and remembrance book inscriptions, will require a quite different style of decoration to ephemeral, informal works, such as birthday invitations, bookmarks and greetings cards. When working with Gothic or Foundational hand, I usually choose a natural theme. Delicate tendrils, flower-heads, leaves or miniature paintings of tiny creatures complement the lines and curves of the text. With Old English lettering and church texts, I usually stylise designs, as this is more in keeping with the age and style of the script. Foundational hand with its rounded letters calls for a more modern and free-flowing style of illumination.

Sources of design can be found everywhere. I would say that the best starting point when designing is simply to look around you. Keep your eyes open to all things and you will be amazed at the richness of pattern and colour that surrounds you. Jot down shapes, colours and descriptions in a sketchbook, or use a camera to record your ideas. For lettering ideas, look at posters, letters on shop-fronts, and stone or wood carvings. Visit museums and libraries to see the work of ancient scribes and illuminators. By studying historical manuscripts, ideas will form for your own designs.

Nature has created a wealth of different colours, shapes and textures, and natural themes have always been my particular favourite for illuminated designs. As I live in the country, I am able to study and sketch the wild flowers and fruits that cover the hedgerows and fields. Also, I visit formal gardens, filling my sketchbook with notes and ideas wherever I go. You can see a few examples of my sketches here. Using the wild rose, I have shown how it is possible to develop a sketch by semi-stylising it and then extending it. From the basic sketch, I semi-stylised the design and painted it in watercolour. Then, I drew the same design in red vermilion paint, using a mapping pen. Finally, I extended the design. The capital 'H' at the beginning of this section has been illuminated using this extended design.

Why not try these experiments using your own sketches? Using nature, history, art, architecture and literature as inspiration, you can adapt and interpret the ideas and designs that you see in any number of ways.

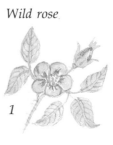

Wild rose

1

2

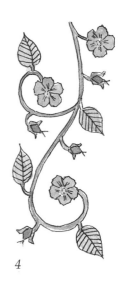

3

Crocus

Forget-me-not

Daisy

Convolvulus

Thistle

Pink

Plum

Wild blackberry

Strawberry

Peach

Cherry

Raspberry

4

Planning your design

The overall design and presentation of your page is as important as the actual lettering or the illumination. There are many factors that contribute to the overall design, including the choice of lettering style and size, the general shape of the layout, the spaces around and between the text, the amount and positioning of the decoration, and the colour scheme. Try to consider all these factors simultaneously, so that you view your piece of work as a whole from the very beginning.

Choose your text, then decide on the size and shape of your layout, remembering that margins and space play a vital part in the design. The choice of lettering is important and should suit the subject matter of the text. The size and shape of the letters will affect the amount of space left for decoration.

At this stage it is worth making a rough pencil draft on a piece of scrap paper. Work out the amount of space that the text will take up, and decide whether you require a highly decorative capital letter with little or no border, or whether you would prefer a simple illuminated capital in gold leaf accompanied by a border design. Whichever you choose, remember that the letter itself should be legible. The size and placing of the initial are also important considerations. Plan your rough carefully and experiment on it until you are happy with both the general layout and the design of your capital letter. The examples on this page give some ideas for different layouts. Experiment, too, with different colour schemes, using a separate sheet of paper on which to test the colours. Once you have finalized all your ideas, you can proceed to transfer your design from the rough draft onto your final paper or vellum.

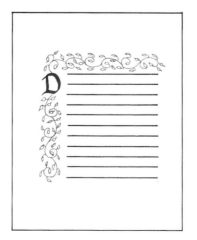

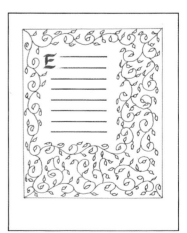

fig 1

fig 2

fig 3

Transferring the initial letter

Having finalized your design, carefully work out the exact measurements of both the text and the capital letter. Rule up your page and draw a box in faint pencil to indicate the position of the capital letter. Write out your chosen text. If you intend having a tinted background, then apply it at this stage, using a thin watercolour wash, see Fig.1. Let the wash dry thoroughly before proceeding to the next stage.

Using a clean piece of tracing paper and a fairly hard pencil, carefully trace off the capital letter and surrounding design from your rough layout. Turn the tracing paper over, position it on a piece of scrap paper and go over the lines of the design with a 2B pencil. Place the traced letter and design over the space for the initial and, exerting a gentle pressure, trace over the outlines of the drawing with a hard pencil, so that the design is transferred to your final surface, see Fig.2.

Now you are ready to paint the design in your chosen colours. Paint the capital letter first, see Fig.3. If you are using gold leaf for the letter itself, then apply it at this stage. Next, paint the surrounding design, see Fig.4. For very complex designs, paint the colours one at a time, e.g. all the green areas, then all the red areas, then all the blue, and so on. Move your paper round as you work to avoid smudging the design, and rest your hand on a piece of scrap paper. Paint the border last of all. If you plan to use any gold on the surrounding design or on the border, then leave this work until the end, as the gold leaf may get damaged with handling, see Fig.5. Erase all pencil lines before laying down the gold leaf.

These, then, are the basic rules for creating illuminated capital letters. With only a little practice and patience, you will soon be able to design your own decorative alphabets.

fig 4

fig 5

imple leaf

The leaf design that I have chosen for this alphabet is based on some leaves which I found lying beneath an elm tree at the bottom of my garden.

I decided upon basic measurements of 2.5 × 3.0cm (1 × 1¼in) for the capital letter and then added the tendrils and leaves to this. Once I was happy with the design, I measured out the box for the capital letter in light pencil and traced my final draft onto the paper. I used black designers' gouache to paint the letter and, when this had dried thoroughly, proceeded to paint the leaves using orange and olive green. I painted the orange colour first, leaving a slight puddle of paint to blend in with the green so as to give a more natural appearance as if the leaves were turning into autumnal colours. When the leaves were dry, I used a mapping pen to draw in the veins of the leaves in a darker shade of green. Finally, I erased all the pencil lines.

On page 25, I have given some alternative suggestions for colouring the alphabet. I have also given examples using maple leaves and holly leaves instead of elm leaves, and I have provided a selection of different leaves which can be superimposed onto the tendrils. You may wish to extend or embellish the design further, and I have shown an example of how to do this on page 26, using the letter E. Firstly, I extended the tendrils and added more leaves. With a mapping pen and sepia ink I dotted all over the area surrounding the capital letter. Then, I dotted the spine of the letter with Chinese white gouache, using a fine brush. As a finishing touch, I added a border to the design in gold leaf. You may have other ideas for embellishing these letters, so why not have a go. You may be pleasantly surprised at what you can achieve. In the example on page 27, I have shown how to extend a letter in two directions, to fit around a short piece of text.

As you can see, this fairly simple alphabet is very versatile, and it can be used equally well for both formal and informal occasions. Foundational and Italic are both suitable hands for any accompanying text.

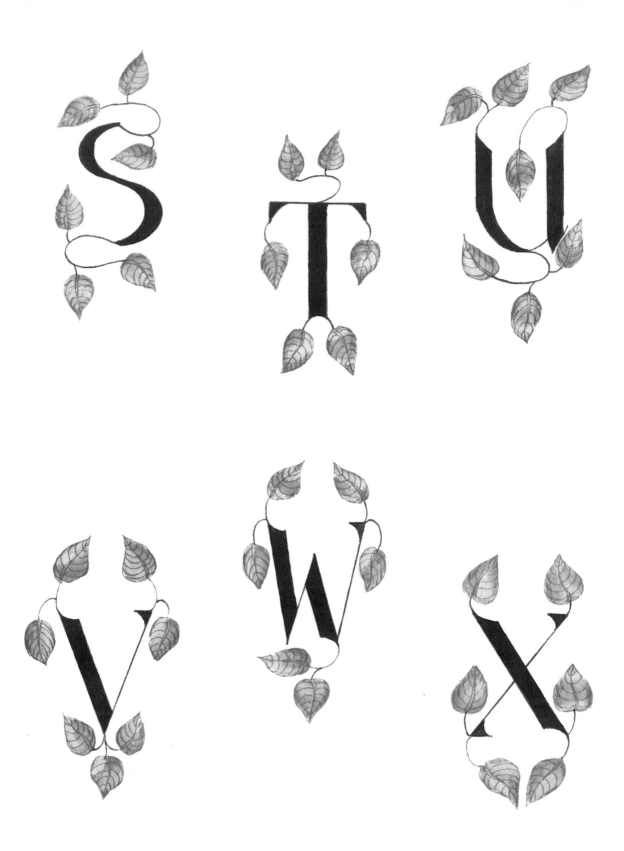

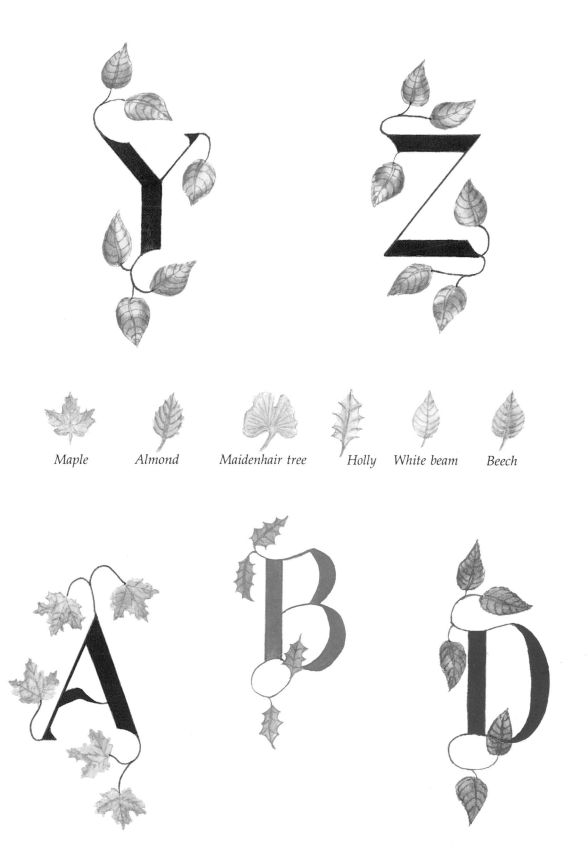

Maple Almond Maidenhair tree Holly White beam Beech

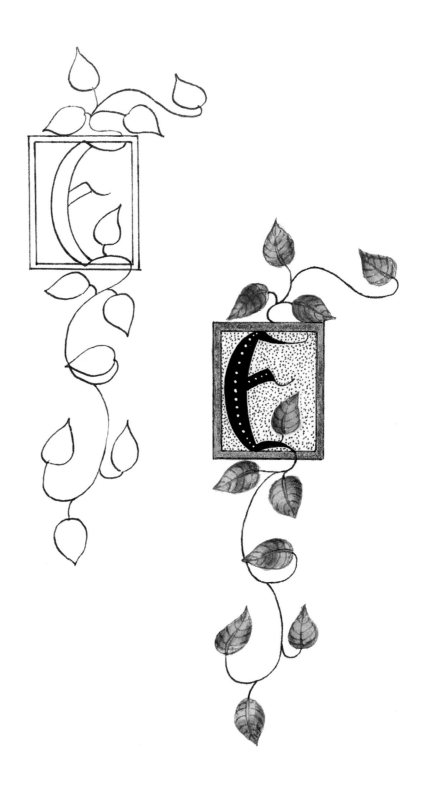

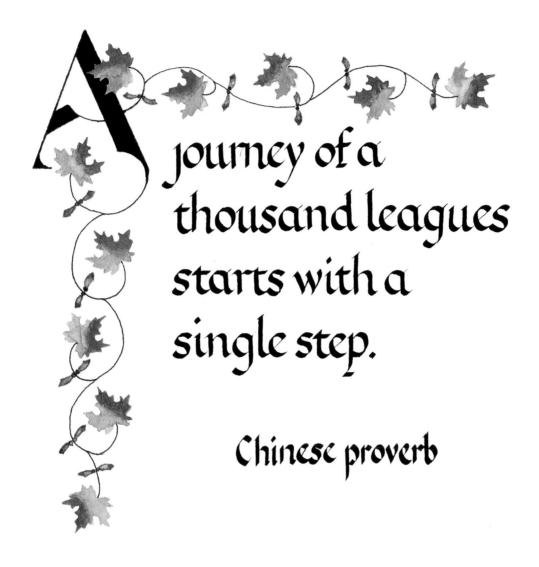

A journey of a
thousand leagues
starts with a
single step.

Chinese proverb

Abstract

This pen-drawn design was not planned, but grew out of a series of doodles which I made on a piece of scrap paper. I often play around with different colours and ideas, adding here and there until I achieve a pleasing design.

Having traced off the letters and surrounding patterns, I proceeded to colour the capitals, using a technical pen and watercolour paints in vermilion and ultramarine. Once the letters were dry, I coloured the designs. Although I have outlined all the designs in either blue or red, you could use black with equal success. I would not recommend using ink as it tends to bleed onto the surrounding paper.

I find this alphabet very versatile, and suitable for modern as well as for formal work. The letters are particularly useful for decorating Roman, Gothic and Foundational texts.

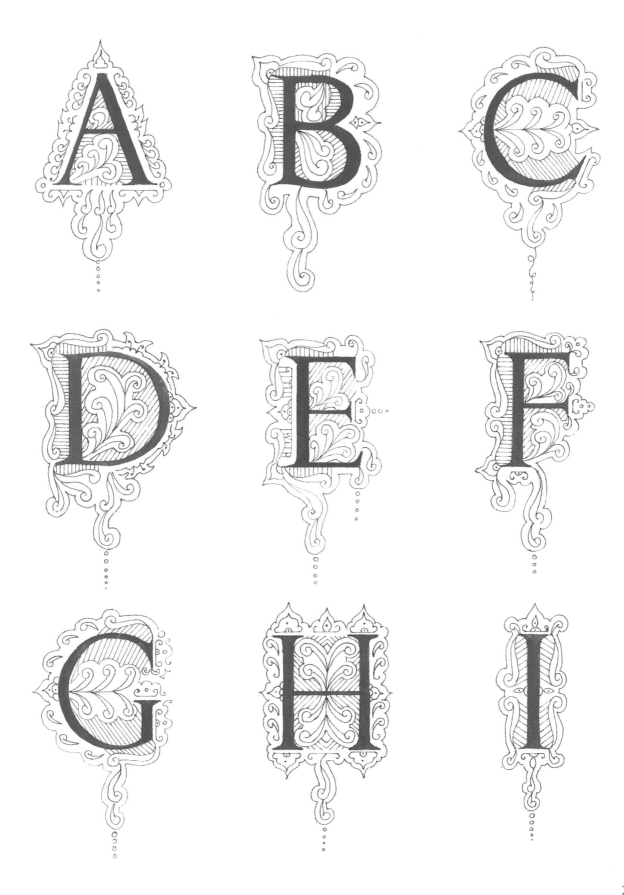

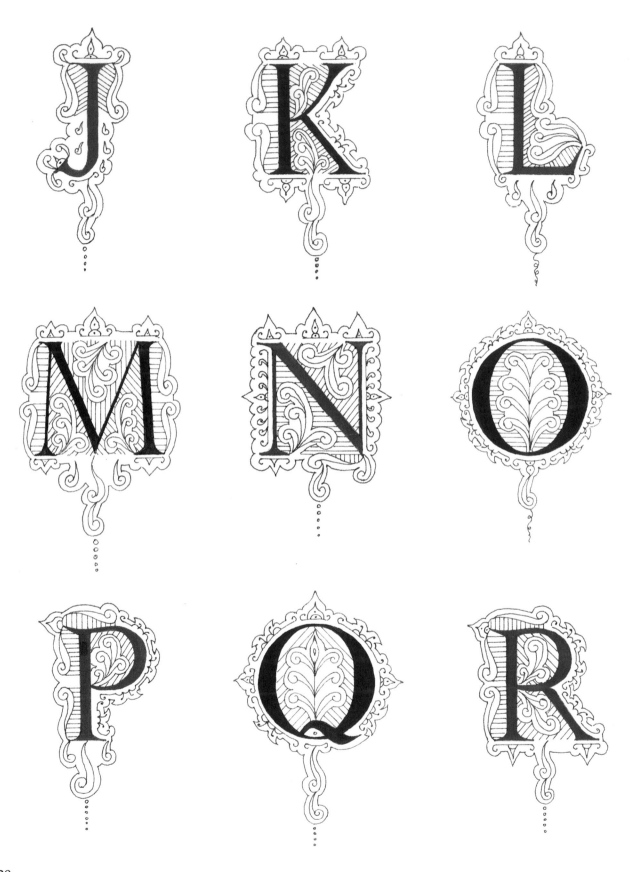

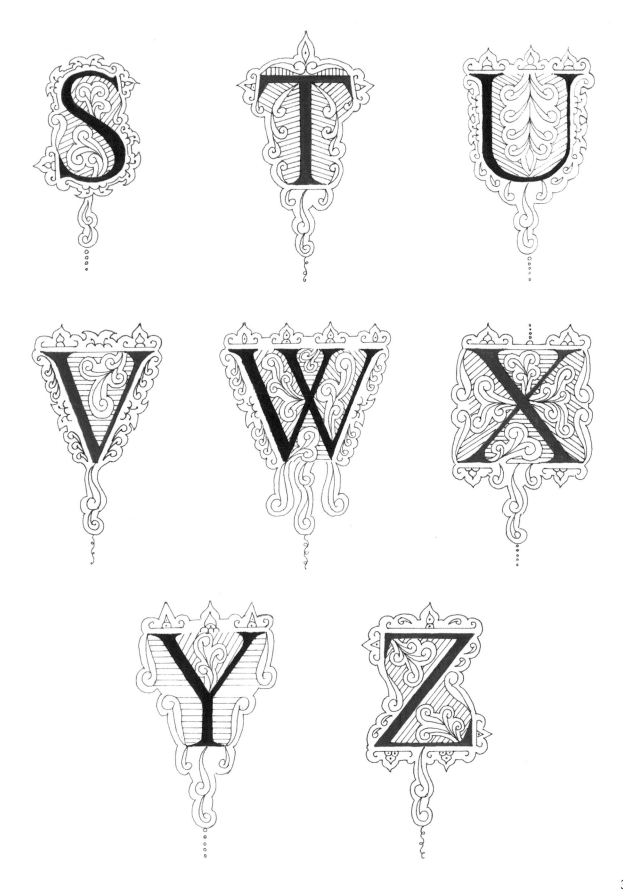

Ribbon and flowers

This ribbon and flowers alphabet may seem reminiscent of Victorian times, although I did not originally design it to reflect this era. I intended it to suggest sunny springtime days and bright, light-hearted occasions.

The letters are not difficult to paint and colours other than red are equally suitable. I painted the ribbon first, using designers' gouache. Then, I painted a faint wash of pale yellow watercolour over the space for the flowers. Using gouache again, I added in the colours for the flowers and leaves in a haphazard way, making sure that I repeated the flowers consistently.

The uses for this informal alphabet are numerous, and it is particularly suitable for occasions such as birthdays, weddings and christenings. Using one of these letters, I embroidered my granddaughter's initial on the corner of a handkerchief for her. Also, I painted a birthday card with her initial enlarged on the front. I am sure that you will have other ideas of your own.

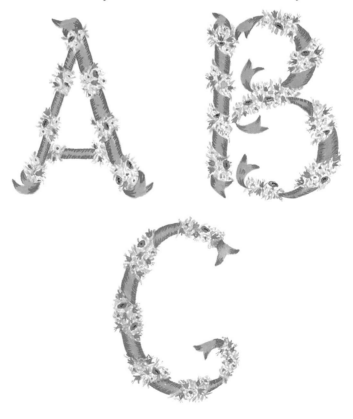

A B C D E
F G H I J
K L M N O
P Q R S T
U V W X Y
Z

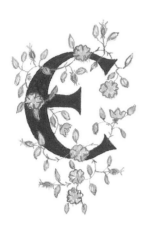# Entwined roses

This delicate rose design which entwines the capital letter was inspired by my walks along the lanes of East Anglia where I now live. These brier-roses grow all over the hedgerows in summertime and the dainty flowers lend themselves very well to almost any kind of artistic interpretation.

Using basic measurements of 3.0 × 2.7cm (1¼ × 1⅛in) for the capital letter, I traced off the letter first and then the entwined roses and leaves. I painted the letter in ultramarine blue and, when this was dry, painted the leaves in olive green and the roses in scarlet which had been mixed with a little white. Next, I darkened the olive green with a dash of ultramarine and, using a mapping pen, drew in the veins of the leaves and the spurs of the roses. Lastly, with a fine brush, I dotted the centres of the roses with a little orange.

I feel that the ultramarine blue used for the capital letter complements the delicate pink of the roses very well. However, you may wish to use a different colour for the letters or even for the roses as well. I have given some alternative colouring ideas on page 38. It is quite simple to adapt this design and to extend it around the verse or text which accompanies it, as I have done on page 39. Try extending the design on a piece of scrap paper first, then trace it onto your final draft.

This alphabet is an informal one and works well with Foundational and Italic hands. If you wish to use it for formal occasions, then try using Old English lettering for the accompanying text.

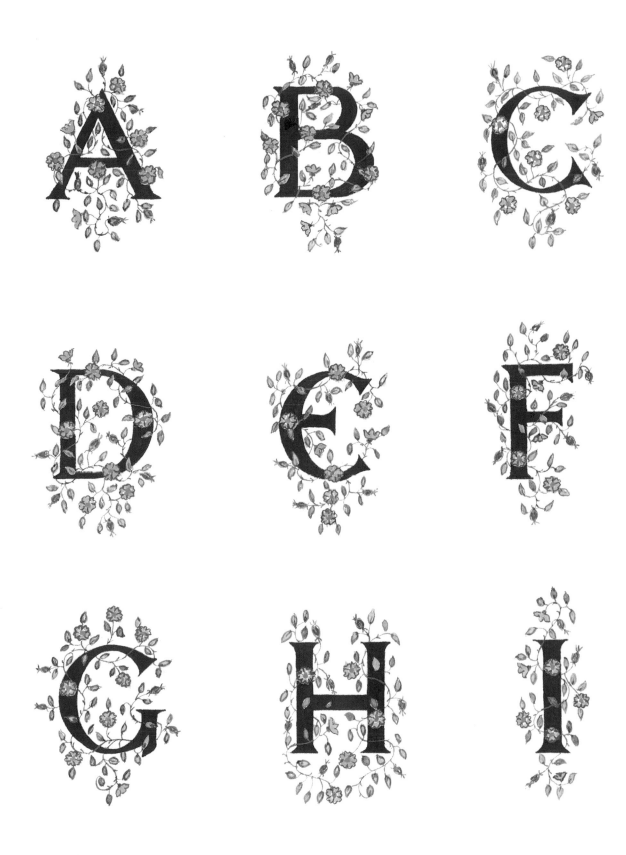

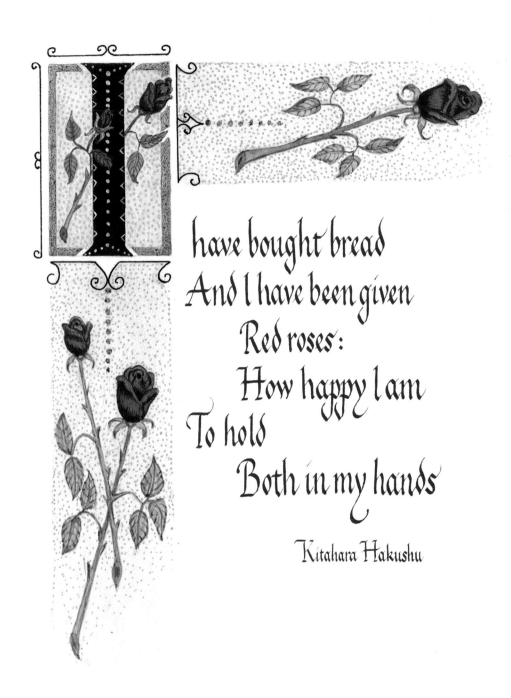

I have bought bread
And I have been given
 Red roses:
 How happy I am
To hold
 Both in my hands

Kitahara Hakushu

Stylised leaf

I have included this alphabet to demonstrate how it is possible to be influenced by illuminators and calligraphers of the past. These letters were inspired by the designs of the Victorian artist Owen Jones. I think that it is very important to be aware of the work of others, from medieval scribes through to contemporary calligraphers, and to learn as much as you can from their different styles and techniques. You may be worried that this may appear to be copying, but it is only by experimenting with as wide a range of ideas as possible that you will eventually develop an original style of your own.

I started this alphabet by playing around with a variety of leaf ideas, adapting Owen Jones's designs in as many ways as I could. From these experiments I eventually developed a design with which I was happy. I traced off the capital letters and leaf designs. Then, I painted the letters, using designers' gouache in vermilion and a mixture of vermilion and white. Next, I painted the surrounding leaves, using ultramarine and a mixture of ultramarine and white. With a very fine brush, I added the tiny white dots last.

I would use these rather romantic letters for a variety of semi-formal occasions.

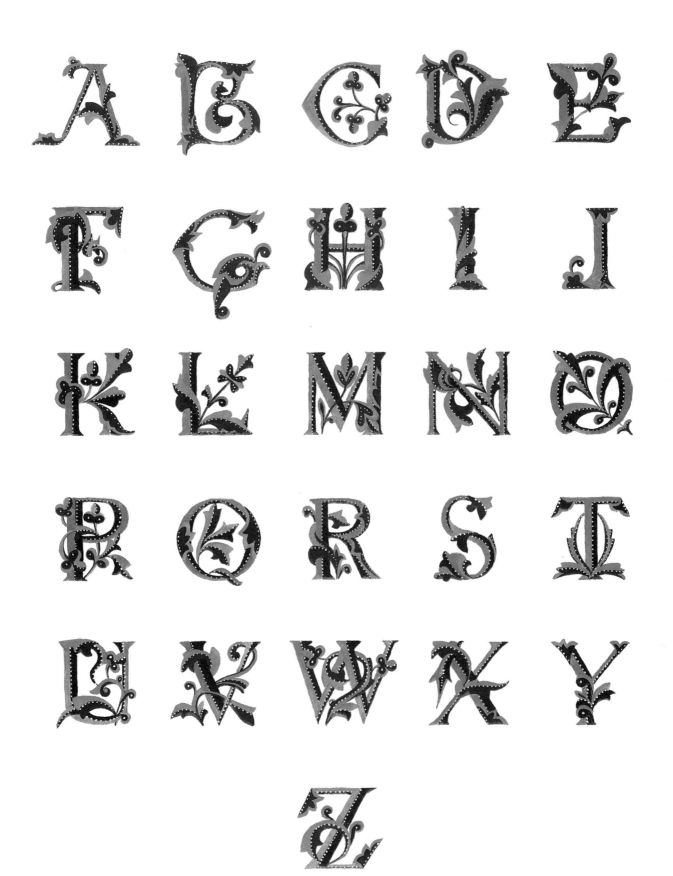

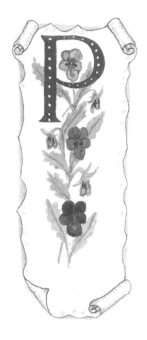

Parchment

This unusual alphabet was created quite by chance. I had sketched an idea for a decorative capital letter and then torn out the letter as it was on a piece of scrap paper. I laid this on top of the paper which I intended using for my final design and noticed that the torn edges cast a faint shadow on the paper. This gave me the idea of drawing a deliberately uneven line around the capital letter and flower design so as to represent the jagged edges of a piece of parchment.

Firstly, I drew the ragged edges of the parchment in light pencil and covered the enclosed area with a faint creamy wash. When this was dry, I traced off the capital letter and surrounding flower design. Then, I painted the letter in ultramarine blue before painting the flowers and leaves. Using a mapping pen and a darker colour, I shaded in the tendrils of the leaves. Next, I painted the faint shadows behind the parchment in pale purple, edged the parchment with some sepia coloured paint, and shaded the scroll edges. Finally, when all the paint was thoroughly dry, I added the white dots to the spine of the letter with a fine brush.

The colours that I have used for the flowers in this alphabet are varied but they are all based upon the natural colours of the flowers depicted. You may prefer to choose your own scheme. The colour of the capital letters can also be altered, although I think that red, blue and black are the most suitable. Whichever colour you choose, make sure that it is strong enough to allow the letters to stand out from the flowers. The only way that this capital letter can be extended is by lengthening the scroll to the size that you require and then adding more flowers, as I have done in the examples on pages 48 and 49.

I would say that this particular illuminated alphabet is suitable for both formal and informal occasions, so, with the exception of Gothic, it is possible to choose almost any type of script to accompany it.

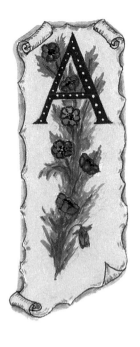
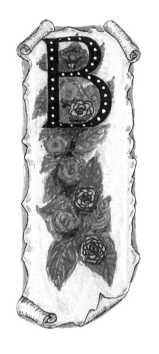

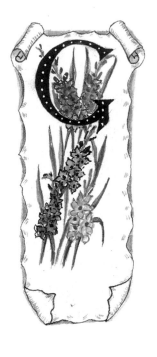

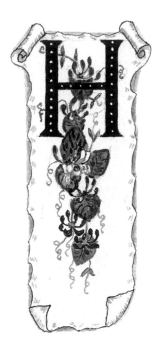

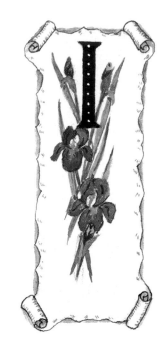

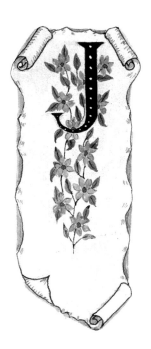

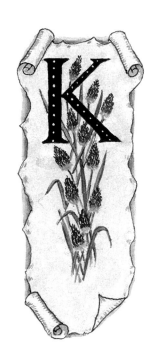

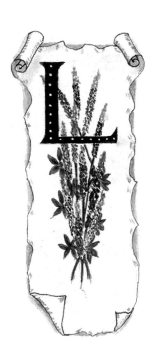

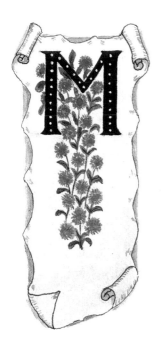

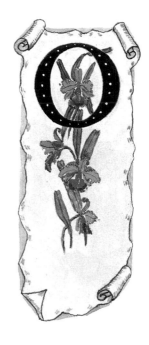

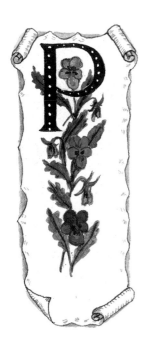

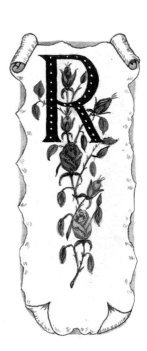

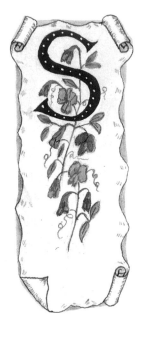
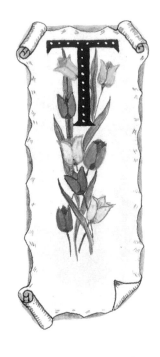
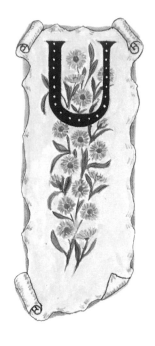
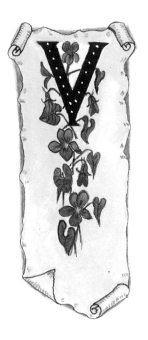

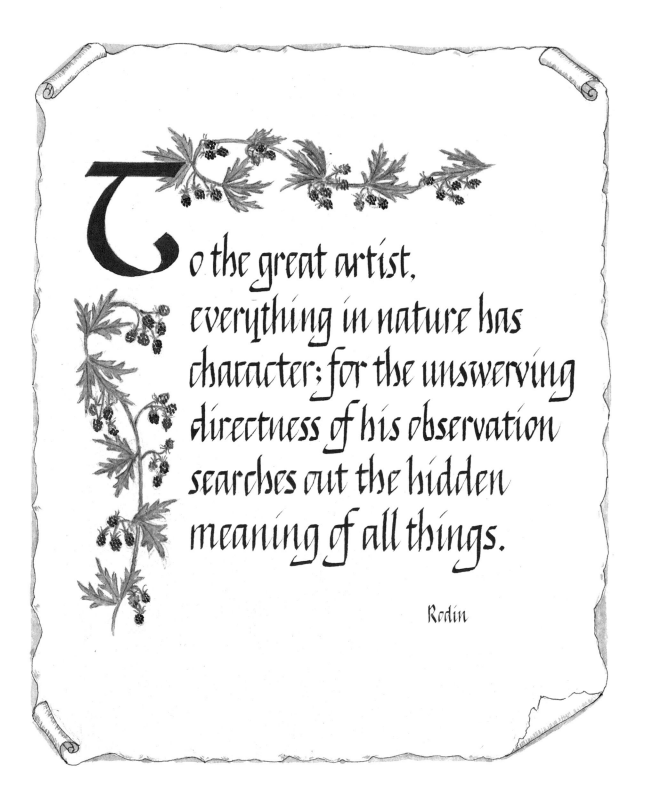

To the great artist, everything in nature has character; for the unswerving directness of his observation searches out the hidden meaning of all things.

Rodin

Classical

Studies of the flowers growing in and around my garden provided the basis for this elegant alphabet. The flowers have been simplified to produce a semi-stylised design.

All the capital letters have a faint watercolour wash as a background. I measured up each square, then, before using any pencil, I applied the chosen colour wash. When this was thoroughly dry, I added the capital letter and flower design in light pencil. Using designers' gouache for both the flowers and the letter, I painted the flowers first. This avoided the possibility of the stronger colour of the letter bleeding onto the surrounding design and preventing the use of more delicate colours for the flowers. Finally, I painted the capital letter.

This alphabet may be used exactly as it stands, but, for the more ambitious of you, it is possible to embellish the letters further, by extending your design below and above each one or by adding a coloured or gold border. If you wish to add a gold border, then remember to leave this until last, following the instructions for gilding on pages 14–15. You can also add dots as an all-over background, using either a technical or a ball-point pen. Again, these should be left until the rest of the design has been completed, but added before any gold is applied. Another alternative is to reverse the colouring of the design, as I have done in the example on page 55. I painted the background in ultramarine blue, the letter in cream, and the flower pattern using my original colour scheme. Lastly, I added a gold border. This example gives a good idea of what the letters might look like if painted on coloured paper, for use on items such as greetings cards and bookmarks.

The letters in this alphabet are suitable for all occasions, although personally I would prefer to reserve them for formal purposes.

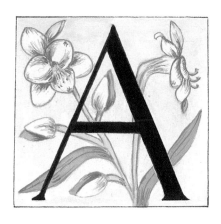
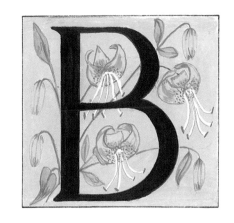

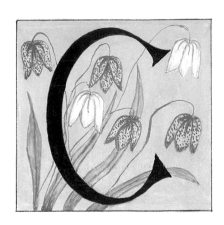
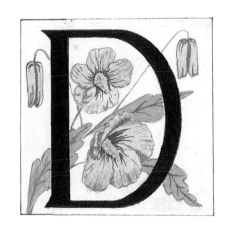

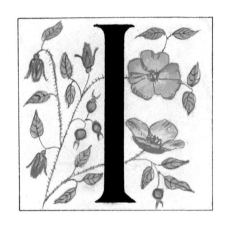

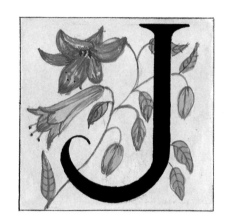

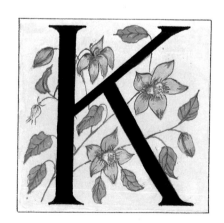

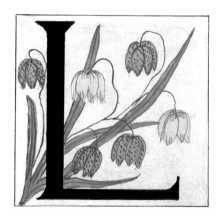

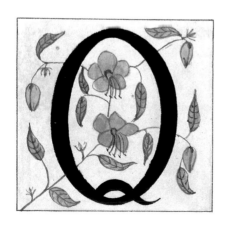

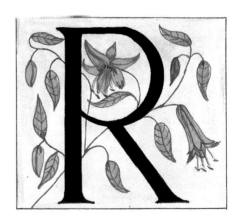

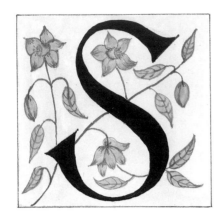

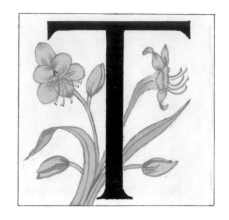

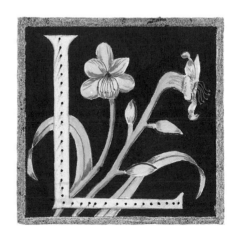

Harlequin

I describe this last alphabet as a harlequin one because of the many colours, designs and techniques that I have used. Some of the capitals have an Eastern flavour, whilst others are entirely modern. Several have extended designs and some even contain miniature scenes and landscapes. They are really intended for the more ambitious of you who find a challenge in painting very intricate details, although many of them could be adapted or used as a basis for more simple designs. All of the letters have been painted in watercolour and gouache, following the same basic procedure as given for the other alphabets in this book.

The more experienced you become, the more elaborate the designs you will be capable of producing. On page 64, I have given an example of a fully illuminated page. In this design, which is based on the type of work created in medieval times, the text and decorated initial letter are totally surrounded by a complex border. The border itself is an amalgamation of some of the design ideas that I have covered in the book and includes flowers, fruit, butterflies and insects, all of which have been semi-stylised to give an impression of the past.

I started by measuring the page and checking the size of the text. Having decided to place the text off-centre, I made a rough sketch of the whole design. On my final piece of paper, I pencilled a box for the text and capital, and traced off the letter. Once the text had been calligraphed, I painted the initial. Then, I traced off the border design. Mixing up more colour than I needed, I proceeded to paint the border, one colour at a time. As I painted, I moved the paper round to avoid smudging the design, resting my hand on a piece of scrap paper. I used a mapping pen for the outlines. Finally, I applied the fine gold border between the text and the painted border design.

Most of the alphabets that I have designed for these pages will blend with the borders to be found in my companion book *Illuminated Calligraphy*. I hope that together they will inspire you to create beautiful illuminated texts of your own.

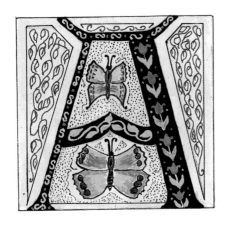

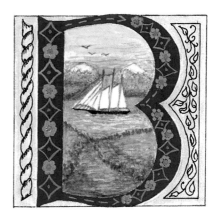

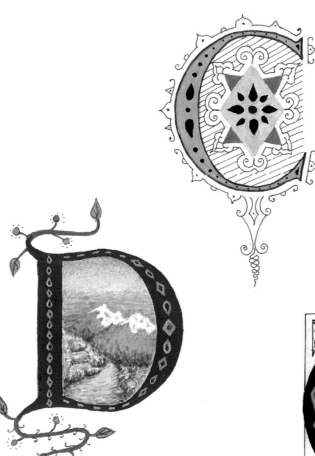

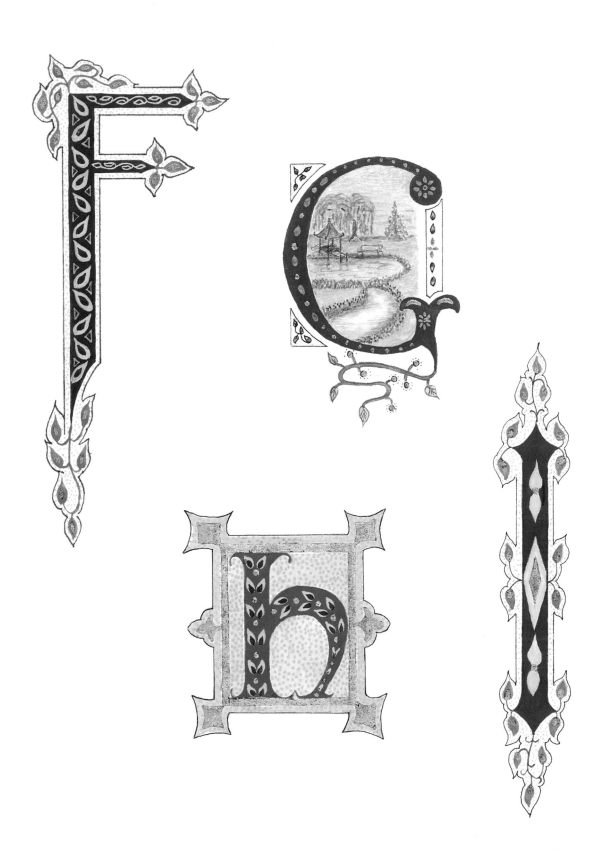

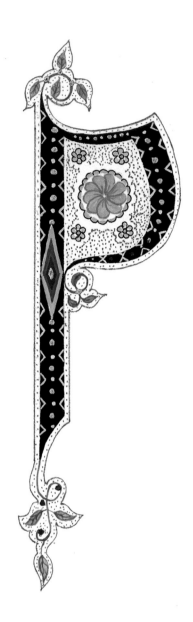

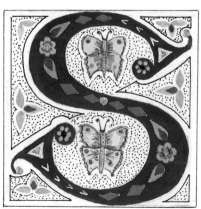

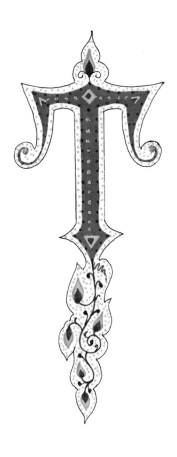
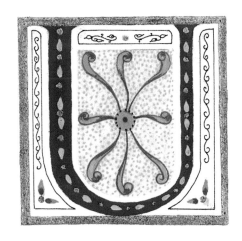
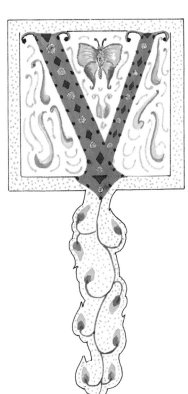

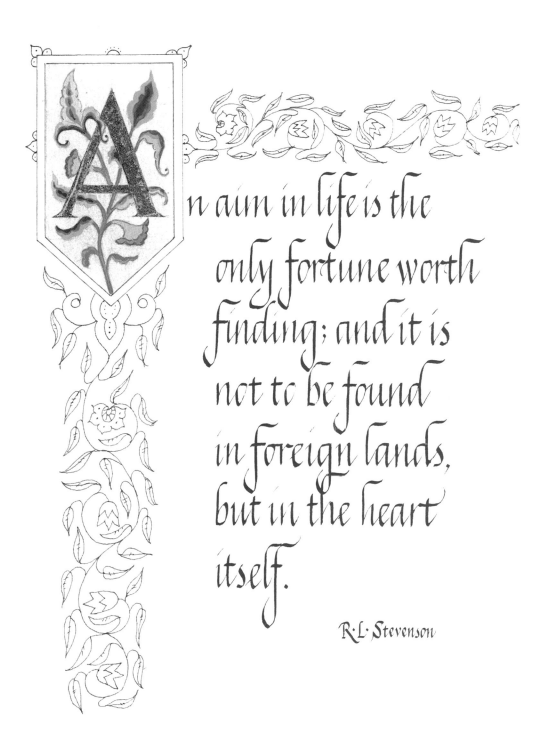

An aim in life is the only fortune worth finding; and it is not to be found in foreign lands, but in the heart itself.

R·L·Stevenson

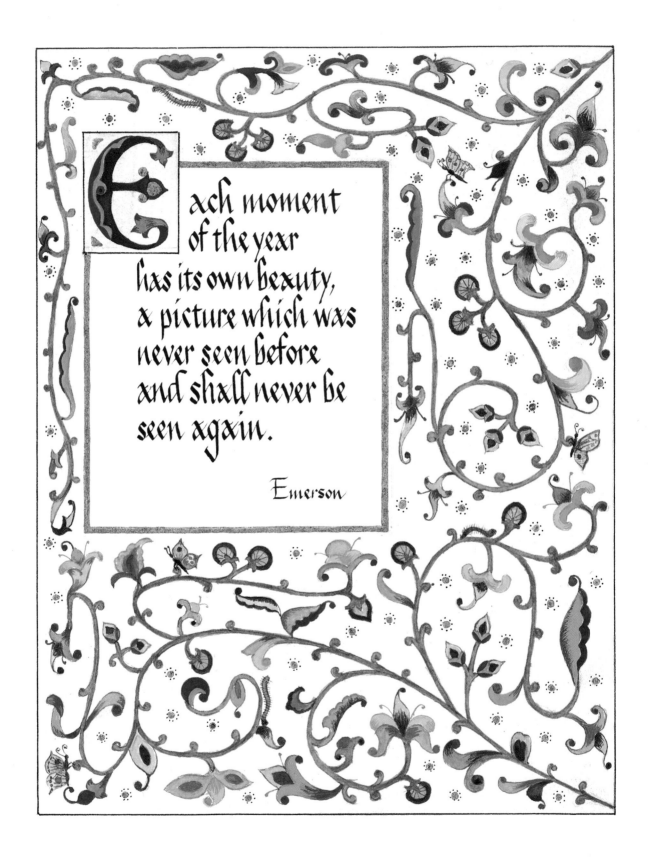

Each moment
of the year
has its own beauty,
a picture which was
never seen before
and shall never be
seen again.

Emerson